# HORSES
# & PONIES

## By Patricia Getha

Designed by Shelley Baugh
Copyeditor: Meghan O'Dell
Production Design by Debbie Aiken

Walter Foster Publishing, Inc.
3 Wrigley, Suite A
Irvine, CA 92618
www.walterfoster.com

© 2010 Walter Foster Publishing, Inc. Artwork © 2010 Patricia Getha.
All rights reserved. Walter Foster is a registered trademark.
This book has been produced to aid the aspiring artist. Reproduction of work for study or finished art is permissible.
Any art produced or photomechanically reproduced from this publication for commercial purposes
is forbidden without written consent from the publisher, Walter Foster Publishing, Inc.

# CONTENTS

# INTRODUCTION

It has been said, "There is nothing more beautiful than a horse." I can think of a lot of beautiful things, but horses are high on my list of favorites, from a foal taking its first tentative steps to a stallion galloping full-speed across a grassy plain. Horses hold a special place in the hearts of many, and have been depicted in numerous art forms for thousands of years. They have been painted by prehistoric man on cave walls in France, and cast in bronze or terracotta and carved from stone in ancient China. In Europe and Asia, leaders were often sculpted or painted astride their noble steeds.

Today, equine art is once again gaining popularity in the art world. There are many accomplished modern-day artists who have made their mark by drawing, painting, or sculpting the equine form. Many of us have been drawing horses from an early age, and some have been teased about our ingrained, sometimes insane desire to draw these beautiful creatures. This love of "all things horses" may be suppressed for a time, but it often resurfaces later in life and usually never disappears completely. You horse lovers know exactly what I'm talking about!

You don't have to be a horseman to love or draw horses. I went for many years without owning or even being around horses. When drawing horses, take advantage of opportunities to observe live equine subjects. Study the anatomy of live subjects, taking special note of body language, as horses "talk" with their bodies. For instance, pinned ears and wide eyes may indicate dominance or anger toward another horse or a person. A swishing tail and a raised leg could be a warning of an impending kick. Ears up and forward are usually an indication of alertness. Relaxed, sagging ears could indicate boredom or just plain sleepiness. All these nuances can be translated in your drawings.

While it is always better to have live subjects to study, accurate photographs can help you draw realistic equines as well. Start a collection of photos of the subjects you like to draw. As you get better, try photographing your own subjects. Most of my reference material comes from my own photographs, but I still keep a file for the times when I might need a second reference. Some of the pictures in my file are more than 40 years old! Many of the horses are no longer living, but their captured images provide valuable information that can be used for many years.

Most importantly, keep practicing. The more you draw, the better you will get, even if you have been drawing for a long time. Don't be afraid to make mistakes. I suggest that you keep your old drawings in an acid-free sleeve or portfolio so you can reflect on them and see the progress you make over time.

# TOOLS & MATERIALS

One of the nicest things about drawing with pencil, charcoal or black wash is the fact that the materials are simple and very portable so they can be taken with you in the field. They are not terribly expensive either! As you experiment with various drawing techniques, you will find what works best for you. The following tools and materials are what work for me. Feel free to experiment with other tools, papers and techniques. There is always more than one way to draw.

**Brush** This inexpensive brush (A) is typically used for brushing sauces on meat before cooking and can be picked up in any grocery store. I use it to brush away eraser crumbs and other debris from the surface of the paper. It works very well!

**Stick Eraser** A refillable stick eraser (B) is useful for getting into tight places. You may want to use it in conjunction with the erasing shield.

**Pencil Extender** Get the most out of your pencils! Use a pencil extender (C) to lengthen short pencils.

**Blending Tools** Tortillons (D), sometimes called blending stumps, are used for blending shades of graphite or charcoal and for softening edges. When the tip gets dirty, you can clean it by rubbing it on a kneaded eraser.

**Kneaded Eraser** A kneaded eraser (E) is a very useful tool. It can be shaped to get into tight places or can be flattened to lift graphite or charcoal from the paper, and it won't damage the surface of the paper. It also doesn't leave annoying crumbs.

**Erasing Shield** Use this shield (F) for protecting areas that you do not want to erase.

**White Plastic Eraser** Useful for erasing larger surface areas, this eraser (G) does a nice job of lifting out darker values. Use it with care so you don't damage the paper.

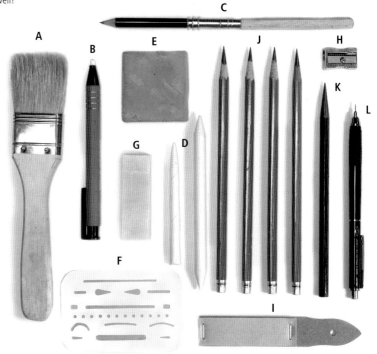

**Sharpeners** A hand-held sharpener (H) will give your pencils sharp tips. You can use the fine point for thin lines and details, and you can use the side for shading with broad strokes. A sandpaper block (I) gives you more control over the shape of the point. Gently roll the pencil tip over the block for a round, even point—or flatten the lead into a blunt, squared tip.

**Pencils** Pencils come in a vast array of options. You can try different kinds to find those that work best for your drawing style. Some of the types available are wood-cased (J), woodless (K), and mechanical (L). Pencils also come in varying degrees of hardness. H pencils are hard and are best for light sketches, and B pencils are softer and suitable for shading different areas of your subject. The higher the number preceding the letter, the harder or softer the pencil will be. For example, a 4H pencil is very hard and produces a light shade of graphite, whereas a 9B is very soft and yields a dark, rich mark.

Note that hard pencils can dent your paper, so use them with a light hand. I typically start my initial drawing with an HB pencil, which is equivalent to a standard #2 pencil. The pencils I use most often are HB, 3B, 4B, 6B, and 9B. I can achieve a wide range of values using these pencils. Anything over a 6B should be reserved for the darkest areas of the image.

◀ **Watercolor** You may want to add simple watercolor washes (thin layers of paint) to your drawings to give them some extra pizzazz. For this, you'll just need a few paintbrushes (I prefer sable brushes), a tube of black watercolor paint, and a palette for mixing different values. You should also have paper towels handy for wiping excess water off the brush. You may want to try out some painting techniques on scrap paper before applying washes to your drawing.

▶ **Charcoal** Like pencils, charcoal is available in several forms. Charcoal pencils also come in varying degrees of hardness, but not as many as graphite pencils. You can also buy raw charcoal sticks. Some artists even use burnt wood scraps from their own fireplace. When blending charcoal, use the same tools you use to blend graphite.

**Light Table** A light table is useful for transferring your preliminary drawing to a clean sheet of paper. You can also use it to refine your initial sketches by tracing your image onto another sheet of paper.

**Paper** I believe that paper plays the most important role in the quality of your drawings. I recommend getting a small sketchbook for drawing on location or sketching out ideas. For the final drawing, use an acid-free paper that is suitable for graphite or charcoal. Acid-free papers withstand the test of time, provided they are stored and framed properly. Most papers can be purchased by the sheet or in pads.

If you will be incorporating watercolor washes into your drawings, look for cotton rag paper, which accepts watercolor and graphite or charcoal very well. When choosing a watercolor paper, I prefer hot-press paper (as opposed to cold-press), which has a smooth, almost slick surface that allows for flawless washes that are easy to control. Thicker papers work better for watercolor and will not curl as easily. Another option is to purchase a watercolor block, which is a pad of paper that is bound on all four sides to keep it from curling. When you are finished with your drawing, simply slip a dull knife under the edges to separate the top sheet from the block.

The tooth of the paper, or the roughness of the surface, is another important aspect to consider. "Toothy" papers can hold a lot of graphite or charcoal but do not hold up for wet media like watercolor. The more tooth the paper has, the less durable it is when it comes to erasing. The fibers will get worn with repeated erasing, so be careful not to overwork areas.

Another thing to note when choosing paper is whether you plan to reproduce your drawings. The texture of the paper will sometimes reproduce when printed, which can be undesirable in some cases. Paper in its natural state typically has a yellow cast to it, which can be difficult to eliminate when reproducing the drawing. Scanners sometimes read the texture or color cast as a value or shades of gray, which will affect the overall contrast of your drawing. I use a bright white paper for drawings that are going to be reproduced. These papers are often bleached or have special whiteners added to them in the manufacturing process.

# ANATOMY & FEATURES

Just like people, horses come in many different body types and sizes. Horses are measured in hands, and one hand is equivalent to 4 inches. The tallest horse in the world is nearly 20 hands tall (from the ground to the highest point of the withers), and the smallest is a little more than 4 hands—17.5 inches, to be exact!

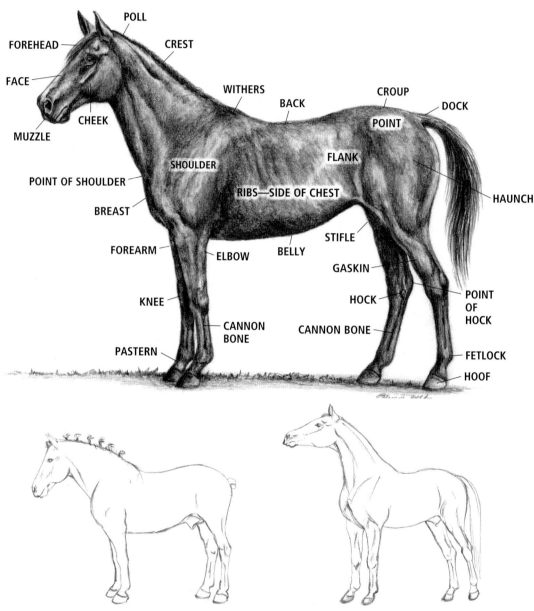

**Comparing Body Types** You can easily see the difference in types of horses through simple line drawings like these. Some horses such as the Percheron, Clydesdale, Shire, and Belgian are heavy-boned draft breeds with thick necks and muscling over their bodies. These horses were bred to work!

The Arabian and Thoroughbred are fine-boned horses that are bred for stamina, endurance, and speed. Both of these breeds are very versatile and are used in racing, eventing, and as general pleasure horses. The Arabian in particular is widely used as a competitive endurance and trail horse, traveling as many as 100 miles in one day.

Sometimes horses are trimmed or shaved to accentuate different parts of their anatomy, such as the jaw line, ears, muzzle, legs, and fetlocks. When looking at reference photos, notice the detail of the ears. The inner ear area is often shaved on show horses, giving them a streamlined appearance. The long, thick hair in the ear acts as a barrier that prevents insects and debris from getting into the ear canal.

Areas around the eyes and muzzle are often shaved clean of whiskers, which horses use to feel where they are in relation to their surroundings. The whiskers are attached to sensitive nerves that help the horse feel where its face is, preventing possible injury to those sensitive areas. Cats, dogs, and other mammals have whiskers for the same reason. Every part of the horse's anatomy serves a purpose!

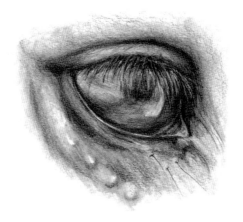

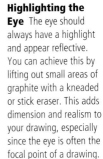

**Highlighting the Eye** The eye should always have a highlight and appear reflective. You can achieve this by lifting out small areas of graphite with a kneaded or stick eraser. This adds dimension and realism to your drawing, especially since the eye is often the focal point of a drawing.

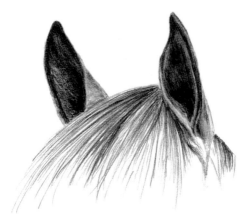

**Ears** The ears of the horse are one of the most expressive parts of the anatomy. You can often gage a horse's mood by the position and movement of the ears. You can tell when the horse is sleepy, angry and aggressive, alert, or frightened. This drawing shows an ear that has been trimmed free of hair. The darkest shading will be in the deepest part of the ear, blending to a lighter value.

**Muzzle** In the summer, the muzzle is often devoid of hair and has a somewhat shiny appearance, especially in professional photos. Light oil is often applied to the eye and muzzle in photos and drawings to accentuate and define these areas. You can reflect this in your drawings by carefully blending these areas and using the kneaded eraser to lift out graphite for highlights.

# EXAMINING PROFILES

The following five profile drawings are a small sampling of the differences in some common breeds. Note the shape of each profile; many times the profile of the head is characteristic of a particular breed.

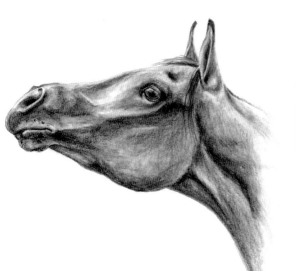

**Arabian** This refined, fine-boned horse originated in the deserts of the Arabian Peninsula. Known for its speed and stamina in extreme conditions, the Arabian's beauty and grace are unparalleled. Arabian bloodlines have long been used to establish new breeds, as their qualities are very desirable.

**American Quarter Horse** A compact breed originating in North America, the American Quarter Horse is known for its speed and durability at a quarter-mile sprint. Primarily bred as work horse and often used in ranch work, today's Quarter Horse is found across the globe.

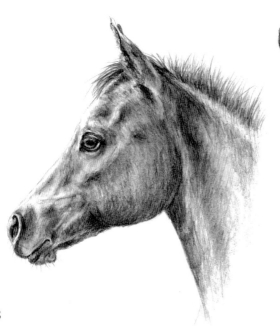

**Pony of the Americas** This foal is a miniature version of the larger Appaloosa horse. The pony possesses the same characteristics as its larger cousin, including spots, but the pony measures between 46 and 56 inches, making it the perfect size for children to mount.

**Haflinger** Native to Austria, the Haflinger evolved in the Tyrolean area of the Alps. The breed takes its name from the village of Hafling, which is now part of Italy. Believed to be a horse with Arabian influence, the Halflinger is small in stature but mighty in heart. Its stocky build has made it a good workhorse as well as a good mount for numerous disciplines. Always chestnut in color, varying in shade from blonde to dark chocolate, its mane and tail are long, thick, and flaxen to white in color.

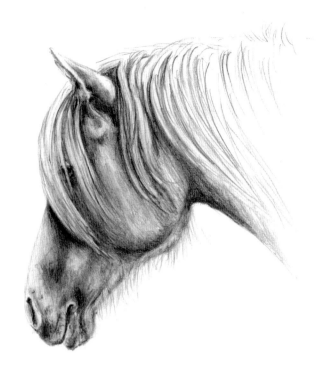

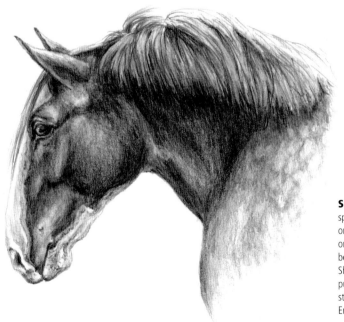

**Shire** A large, big-boned draft breed specifically bred for heavy work, this horse originated in the Shires of England and is one of the world's largest breeds. It can be black, brown, or gray in color. Today's Shires make beautiful parade horses, pulling large, decorative wagons, and can still be seen in their traditional roles in England.

# TECHNIQUES

Techniques for graphite and charcoal are very similar to those for watercolor paint (page 11). There are many more shading techniques than the ones covered here, but I'll focus on those I use for drawing animals in general. One of the most important rules is to shade in the direction in which the hair grows, as it makes your drawings look more realistic. Note that graphite is easier to blend than charcoal and is also easier to erase or lift from the paper. For each technique shown below, you'll see an example in graphite at the far left and an example in charcoal at the near left.

**Gradation**  Start with a soft pencil such as a 6B and turn the pencil on its side. With a good amount of pressure, lay in the darkest value, gradually lessening the pressure as you move down. You may switch to a harder pencil as you move to the lighter values. You can also blend strokes by layering them on top of one another.

**Hair**  Using a sharp graphite or charcoal pencil and a sweeping stroke, quickly move your hand in an arc, lifting the pencil from the paper at the end of the stroke. I usually lift the pencil at the end of the hair (from the darkest to lightest). Experiment to find out what works for you. With a little practice, you will master the art of drawing hair.

**Blended Gradation**  These examples show gradated (or graduated) values that were then blended and softened with a tortillon. This technique works well for moving tones into a lighter area, and is the technique that I use most often.

**Erasing** These examples show how tone can be lifted from the page using a kneaded eraser (such as for creating highlights). I find the kneaded eraser to be the most effective for this, as it can be molded to fit small areas or flattened out for larger areas. Remember that charcoal is harder to lift out than graphite.

**Pencil Hardness** Here are examples of how pencil hardness affects value. The banding indicates where a harder pencil was used to shade. By varying the amount of pressure, you can achieve a wide range of values in your drawings.

**Crosshatching** These samples illustrate the way that layering in different directions creates texture and adds interest. If you use this technique, it should be used throughout the drawing for consistency. I typically do not use this technique in my final drawings, but it works well in preliminary drawings.

# Watercolor Techniques

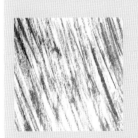
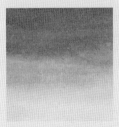
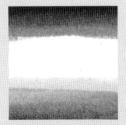

**Drybrushing** Load your brush with a wash of paint and dab the bristles on a paper towel, eliminating most of the moisture. Pull the brush lightly across the paper's surface for a texture that suggests mane and tail hair.

**Gradation** Pull a horizontal band of a wash across the top of the paper. Add more water to your brush as you stroke down, creating a transition from dark to light that can suggest form.

**Wet-on-Wet** Paint wet color onto dry paper or over a dry layer of color. This gives you a good amount of control over the paint's spread, which is great for painting details.

# BASIC PROFILE

In the early stages of your drawing, it's important to establish accurate proportions; you don't want to make major adjustments after you've started adding tone and detail. To get the proportions as precise as possible, use plenty of guidelines to block in the basic shapes. Constantly adjust the lines as you compare sizes, shapes, and angles with your reference. Learning this process of creating and working within guidelines will help you work successfully from your own references.

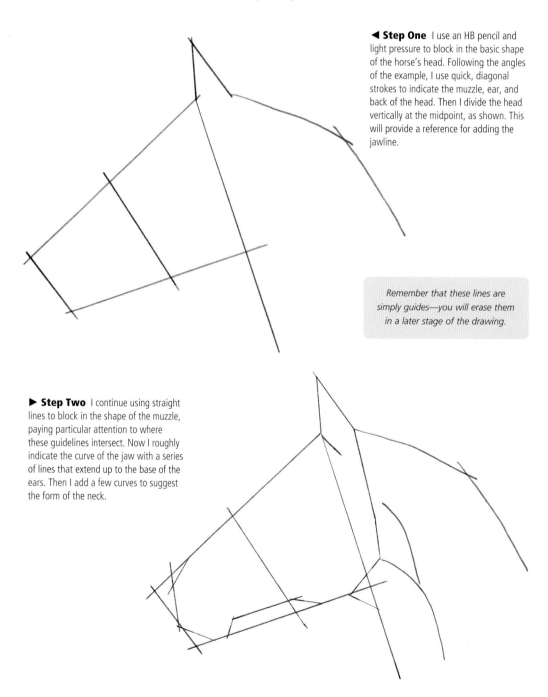

**◄ Step One** I use an HB pencil and light pressure to block in the basic shape of the horse's head. Following the angles of the example, I use quick, diagonal strokes to indicate the muzzle, ear, and back of the head. Then I divide the head vertically at the midpoint, as shown. This will provide a reference for adding the jawline.

*Remember that these lines are simply guides—you will erase them in a later stage of the drawing.*

**► Step Two** I continue using straight lines to block in the shape of the muzzle, paying particular attention to where these guidelines intersect. Now I roughly indicate the curve of the jaw with a series of lines that extend up to the base of the ears. Then I add a few curves to suggest the form of the neck.

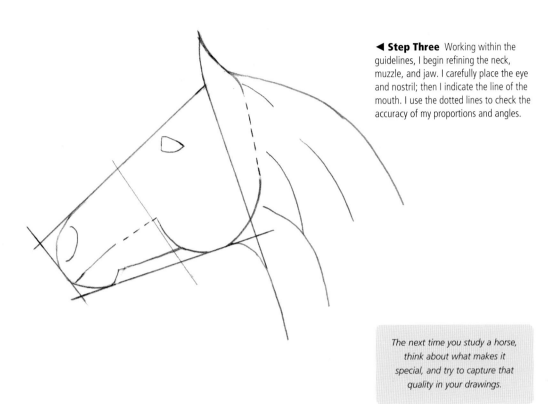

◀ **Step Three** Working within the guidelines, I begin refining the neck, muzzle, and jaw. I carefully place the eye and nostril; then I indicate the line of the mouth. I use the dotted lines to check the accuracy of my proportions and angles.

*The next time you study a horse, think about what makes it special, and try to capture that quality in your drawings.*

▶ **Step Four** I develop the facial features and further refine the outlines, following the subtle curves of flesh around the mouth. Then I block in the mane and forelock with strokes that follow the direction of hair growth. I keep my strokes as light as I can in these initial stages.

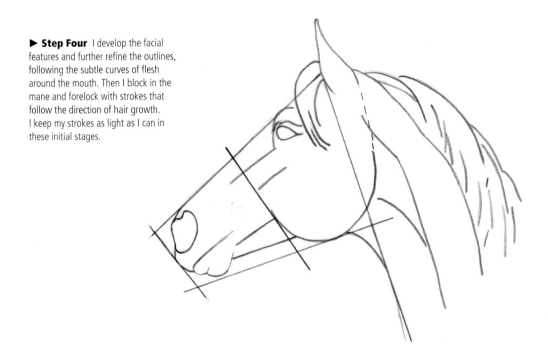

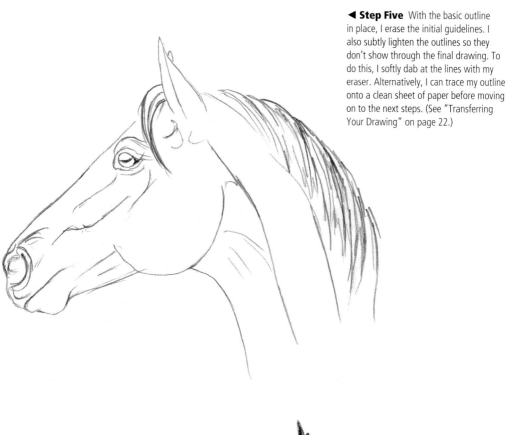

◄ **Step Five** With the basic outline in place, I erase the initial guidelines. I also subtly lighten the outlines so they don't show through the final drawing. To do this, I softly dab at the lines with my eraser. Alternatively, I can trace my outline onto a clean sheet of paper before moving on to the next steps. (See "Transferring Your Drawing" on page 22.)

► **Step Six** I begin applying tone using light pressure, loose hatching, and a 3B pencil. I start with the darkest areas, such as beneath the jawline, in the nostril and eye, and within the mane and forelock. This establishes the general value pattern, which will guide the development of tone and texture of the horse's coat in the next step.

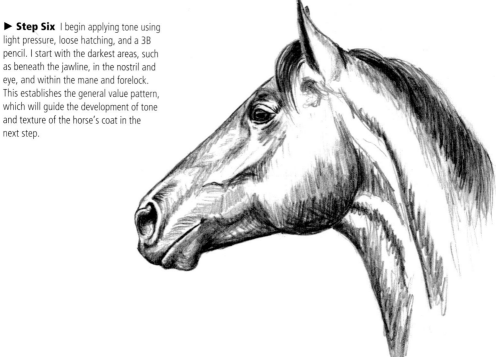

*The Thoroughbred line of horses dates back to the 17th century when English mares were crossed with Arabian stallions. Bred primarily for racing, this speedy horse is known for its natural speed and athleticism.*

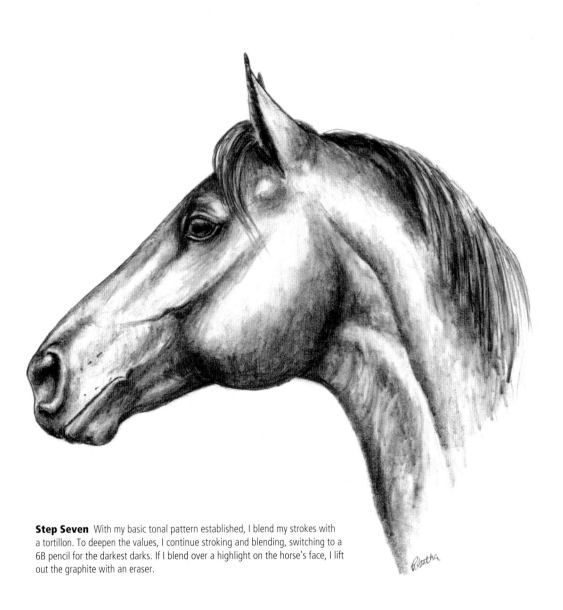

**Step Seven** With my basic tonal pattern established, I blend my strokes with a tortillon. To deepen the values, I continue stroking and blending, switching to a 6B pencil for the darkest darks. If I blend over a highlight on the horse's face, I lift out the graphite with an eraser.

# ADVANCED PROFILE

Once you've mastered the basic profile of a horse, challenge yourself with a more complicated subject. This project includes the horse's tack, which adds interest and intricacy to the composition. This horse also has been completed in charcoal, which offers a richer range of values (and therefore more contrast) than graphite, allowing you to lay in tone quickly without having to apply multiple layers. However, charcoal does not erase easily, so it's more difficult to lift out highlights and remove smudges. A charcoal drawing must be carefully planned and treated with care from start to finish.

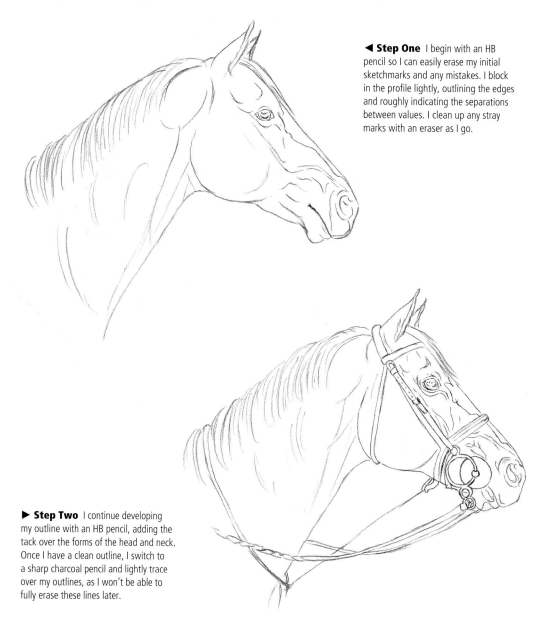

◀ **Step One** I begin with an HB pencil so I can easily erase my initial sketchmarks and any mistakes. I block in the profile lightly, outlining the edges and roughly indicating the separations between values. I clean up any stray marks with an eraser as I go.

▶ **Step Two** I continue developing my outline with an HB pencil, adding the tack over the forms of the head and neck. Once I have a clean outline, I switch to a sharp charcoal pencil and lightly trace over my outlines, as I won't be able to fully erase these lines later.

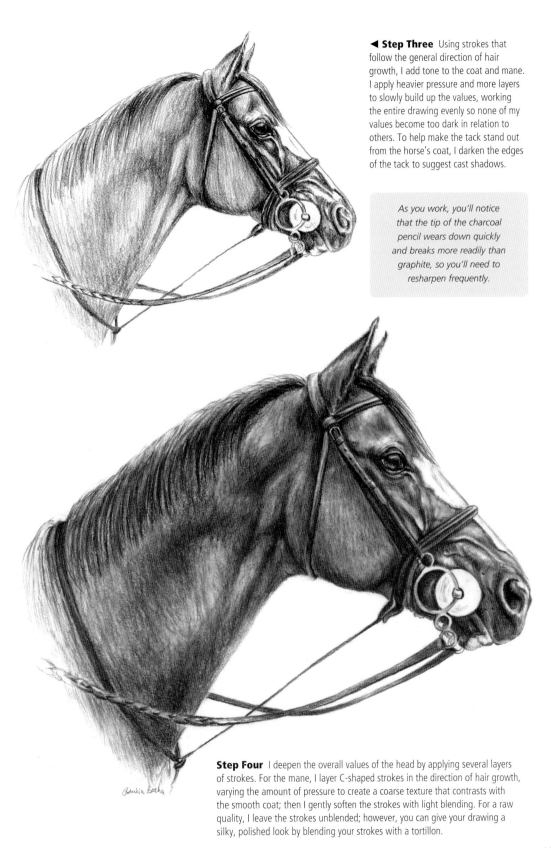

◄ **Step Three** Using strokes that follow the general direction of hair growth, I add tone to the coat and mane. I apply heavier pressure and more layers to slowly build up the values, working the entire drawing evenly so none of my values become too dark in relation to others. To help make the tack stand out from the horse's coat, I darken the edges of the tack to suggest cast shadows.

*As you work, you'll notice that the tip of the charcoal pencil wears down quickly and breaks more readily than graphite, so you'll need to resharpen frequently.*

**Step Four** I deepen the overall values of the head by applying several layers of strokes. For the mane, I layer C-shaped strokes in the direction of hair growth, varying the amount of pressure to create a coarse texture that contrasts with the smooth coat; then I gently soften the strokes with light blending. For a raw quality, I leave the strokes unblended; however, you can give your drawing a silky, polished look by blending your strokes with a tortillon.

# POLO PONY

Although blending may give a polished look to a drawing, it may not be the best approach for your particular subject. To communicate the activity of this polo pony and rider, I choose to keep the strokes sketchy rather than smooth them out with tortillons. This loose appearance contributes to the feel of a quick moment captured mid-game.

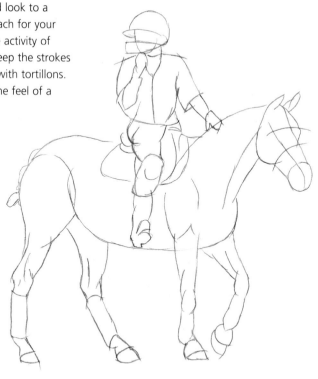

▶ **Step One** Using an HB pencil, I begin by blocking in the basic shapes of the subject. I keep the lines and pencil pressure light so I can alter and refine them in the following steps. I don't worry about the reins and straps at this point—I just focus on the bulk of the rider and horse.

◀ **Step Two** Now I add indications of muscles, tack, and shadows. I start refining any harsh angles to reflect the natural curves of the legs, haunches, shoulders, and facial features; then I refine the lines of the rider. I begin erasing any initial lines that I no longer need.

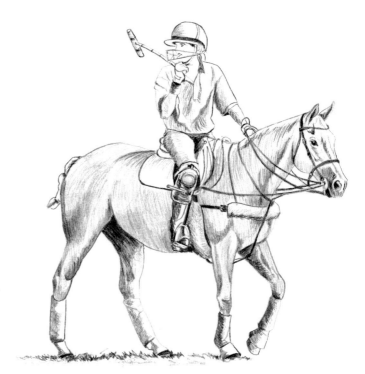

**▶ Step Three** I begin developing form by adding a light layer of shading with an HB pencil. I focus on the areas of shadow, working from light to dark. As I add tone to the coat, I remember to stroke in the direction of hair growth. Then I sharpen the pencil and begin tightening up the straps.

*For the greatest amount of contrast, keep your highlights free of tone or pull out tone with your eraser.*

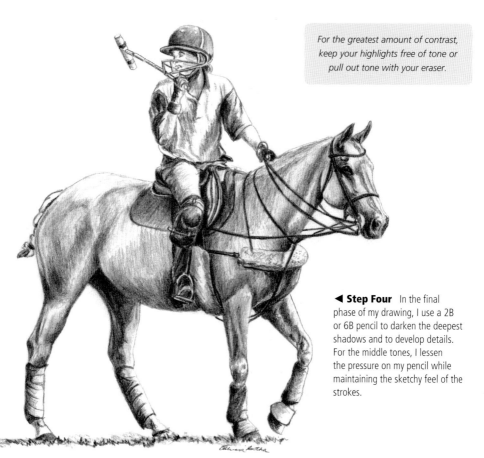

**◀ Step Four** In the final phase of my drawing, I use a 2B or 6B pencil to darken the deepest shadows and to develop details. For the middle tones, I lessen the pressure on my pencil while maintaining the sketchy feel of the strokes.

# ARABIAN PORTRAIT

When searching for a reference, remember that you aren't limited to just one photo; using multiple sources is an effective option. You can use *artistic license* (the artist's prerogative to change a subject or scene) to combine aspects of different photos. For example, if you find one reference with a pleasing composition but can't make out the details, you can use other shots that are better suited to provide this information.

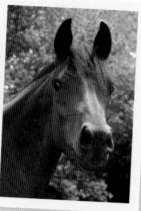

◄ **Combining References** Two photo references were used for this drawing. I prefer the angle of the head and composition in the photo at left, but the horse is out of focus. I used the reference at right to compensate for this, as the details in this photo appear much sharper.

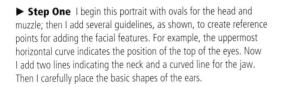

▶ **Step One** I begin this portrait with ovals for the head and muzzle; then I add several guidelines, as shown, to create reference points for adding the facial features. For example, the uppermost horizontal curve indicates the position of the top of the eyes. Now I add two lines indicating the neck and a curved line for the jaw. Then I carefully place the basic shapes of the ears.

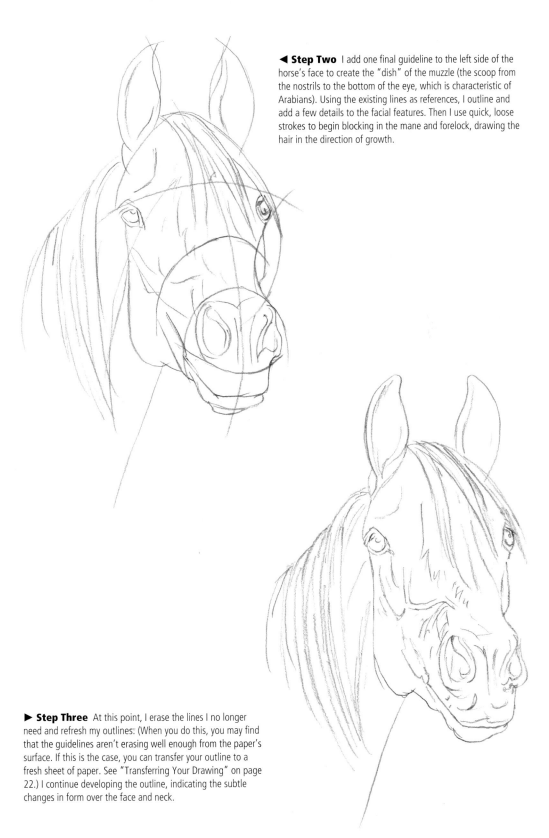

◄ **Step Two** I add one final guideline to the left side of the horse's face to create the "dish" of the muzzle (the scoop from the nostrils to the bottom of the eye, which is characteristic of Arabians). Using the existing lines as references, I outline and add a few details to the facial features. Then I use quick, loose strokes to begin blocking in the mane and forelock, drawing the hair in the direction of growth.

► **Step Three** At this point, I erase the lines I no longer need and refresh my outlines: (When you do this, you may find that the guidelines aren't erasing well enough from the paper's surface. If this is the case, you can transfer your outline to a fresh sheet of paper. See "Transferring Your Drawing" on page 22.) I continue developing the outline, indicating the subtle changes in form over the face and neck.

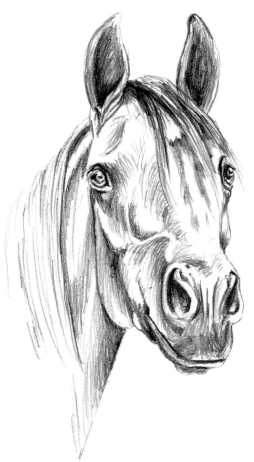

**◄ Step Four** Now I switch to a 3B pencil and begin applying tone to the horse. I hatch in the shadows of the ears, face, and neck, stroking along the curves to suggest form. I use loose strokes, as I will blend them later to provide a smooth coat texture. I gradually build up the value of the forelock with long, light strokes, leaving gaps for areas of highlight.

### Transferring Your Drawing

*Once you've established an outline on your paper, you may find that your initial guidelines and sketch marks are difficult to erase. If this is the case, you can transfer your outline to a fresh sheet of paper. Simply coat the back of your sketch with a layer of graphite, pressing down firmly to create an even layer of coverage. Now turn your paper right-side up and place it over the new sheet of paper. Tape or hold the papers together and lightly trace your outline. The lines will transfer onto the new sheet of drawing paper.*

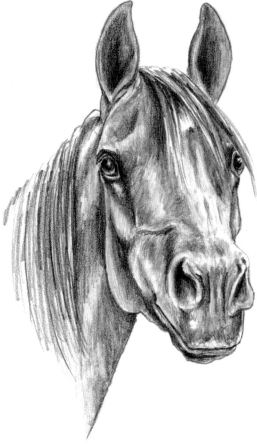

**▲ Step Five** With the basic tonal pattern in place, I develop the shading to darken the overall value of the horse. I use a tortillon to soften and blend the layers of strokes for a more even, unified tone. I build up the mane with strokes of varying values to give it a realistic hair texture.

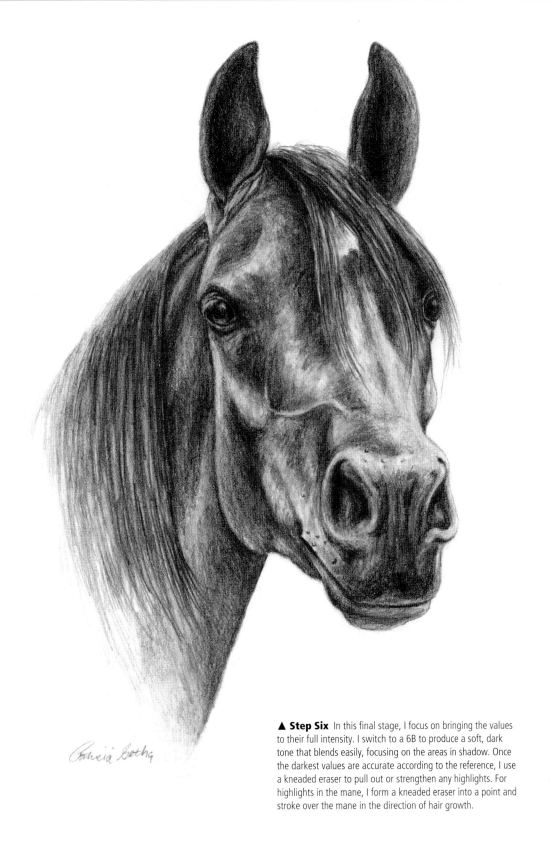

Patricia Botha

▲ **Step Six** In this final stage, I focus on bringing the values to their full intensity. I switch to a 6B to produce a soft, dark tone that blends easily, focusing on the areas in shadow. Once the darkest values are accurate according to the reference, I use a kneaded eraser to pull out or strengthen any highlights. For highlights in the mane, I form a kneaded eraser into a point and stroke over the mane in the direction of hair growth.

# APPALOOSA

The Appaloosa is an American breed descendant from the Spanish horses that were imported by the conquistadores of the 16th century. These unique horses feature four identifying characteristics: a spotted coat pattern, mottled skin, white sclera around the eye, and striped hooves. However, a horse needs only two of these characteristics to be registered as an Appaloosa.

This project demonstrates the *grid method,* which uses simple squares as reference points for transferring a reference to your drawing paper. After following the steps in this project, you'll know how to apply this method to your own reference photographs.

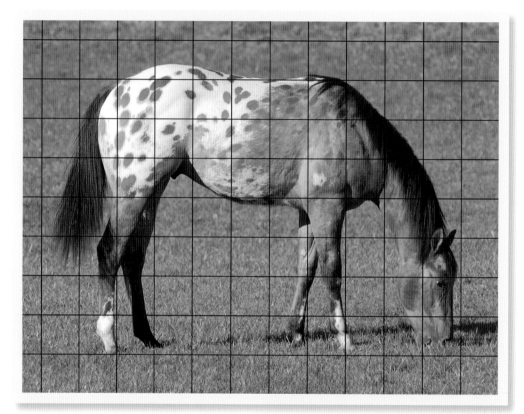

▲ **Step One** To re-create this photograph, I decide to use the grid method, which uses simple squares as reference points for transferring an image to drawing paper. I begin by placing a grid of one-inch squares over a photocopy of my reference using a pencil and a ruler. I refer to this as I place the outline in my hand-drawn grid in step three.

▶ **Step Two** Using an HB pencil and very light pressure, I create a grid of squares on my paper that has the same number of rows and columns as the one placed over the reference.( Remember: If you want your final drawing to be larger than the reference, make the squares of the grid larger; if you want your final to be smaller, make the squares smaller.)

*Appaloosas have several different spotting patterns, including an all-over "leopard" pattern of spots on a white body, a "snowflake" pattern of white spots or flecks on a dark body, and a white "blanket" over the hips with spots that match the rest of the body color (as shown in this drawing).*

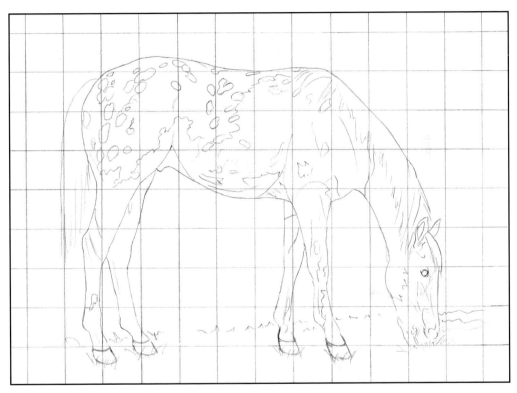

**Step Three** Now I simply create the outline of the horse by copying what I see in each square of the reference into each square of my drawn grid. (You may choose to keep the outline simple and basic, as you always can refine it after erasing the grid—or you can give yourself a thorough guide by adding the facial features and coat patterns.)

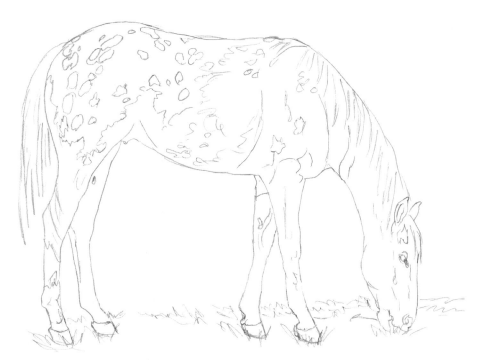

**Step Four** Using the eraser, I gently rub away the grid lines. I try not to rub too hard, as I don't want to damage the surface of the paper. Then I redraw any areas of the lines that have been accidentally erased, restoring the outline as I go. (If you have trouble fully erasing the grid lines, you may want to transfer your outline to a fresh sheet of paper. (See "Transferring Your Drawing" on page 22.)

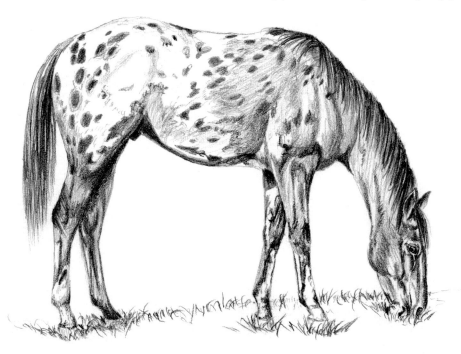

**Step Five** Now I begin working tone into the shadows and across the body using the 3B and 6B pencils. I use layers of graphite to build my drawing slowly— I start out with light pressure, and then I use heavier strokes to develop the muscles and other details. Notice that some of the spots aren't solid—some even contain spots themselves. Noting and capturing these subtleties will add realism to your finished drawing.

*To avoid smudging the lights and highlights with your hand,
cover your drawing with a piece of tracing paper.*

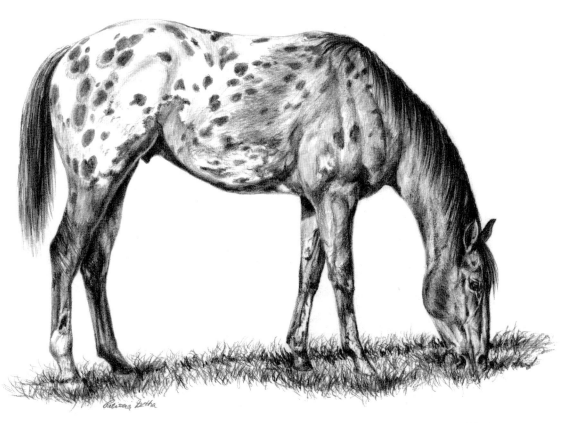

**Step Six** I continue adding value to the horse and grass, working evenly across the drawing. For the light areas of the horse, I use a very light layer of tone to make it stand out from the white of the background. I leave only the brightest highlights free of tone; if I happen to cover them with tone, I simply pull out the graphite with an eraser.

# STANDING FOAL

One of the first things you will notice about a foal, especially a very young one, is the difference in proportion from a mature horse. The legs are considerably longer in relation to the rest of the body, and the joints are more pronounced. Also, new spring foals generally have fuzzy ears; long hair under the jawline; a soft, unruly mane that stands straight up; and a wavy or curly coat. To create an accurate representation of a foal, pay careful attention to these traits.

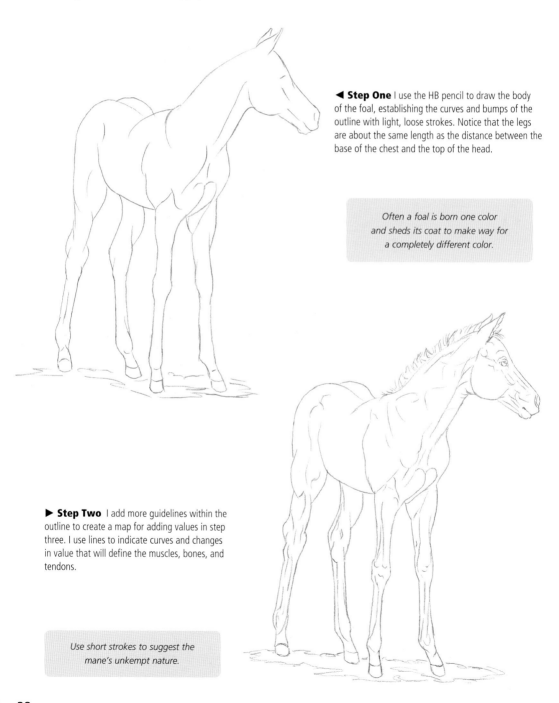

◄ **Step One** I use the HB pencil to draw the body of the foal, establishing the curves and bumps of the outline with light, loose strokes. Notice that the legs are about the same length as the distance between the base of the chest and the top of the head.

*Often a foal is born one color and sheds its coat to make way for a completely different color.*

▶ **Step Two** I add more guidelines within the outline to create a map for adding values in step three. I use lines to indicate curves and changes in value that will define the muscles, bones, and tendons.

*Use short strokes to suggest the mane's unkempt nature.*

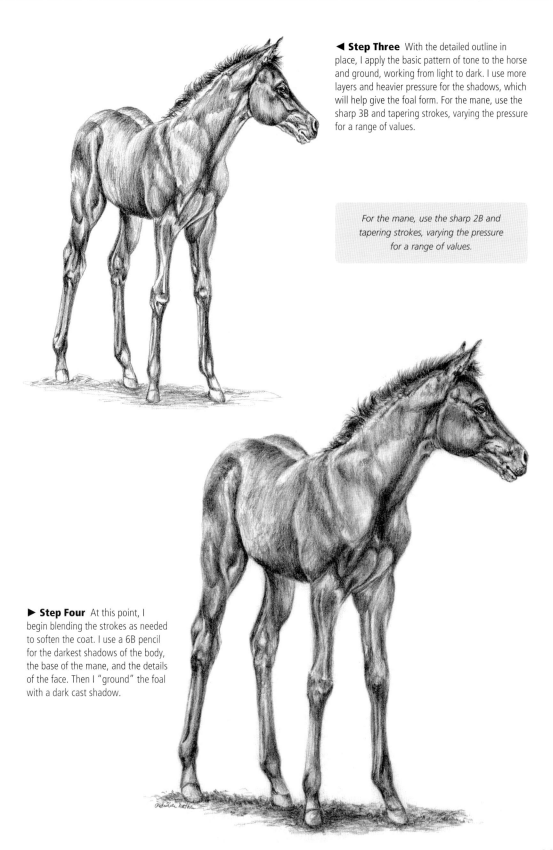

◄ **Step Three** With the detailed outline in place, I apply the basic pattern of tone to the horse and ground, working from light to dark. I use more layers and heavier pressure for the shadows, which will help give the foal form. For the mane, use the sharp 3B and tapering strokes, varying the pressure for a range of values.

*For the mane, use the sharp 2B and tapering strokes, varying the pressure for a range of values.*

► **Step Four** At this point, I begin blending the strokes as needed to soften the coat. I use a 6B pencil for the darkest shadows of the body, the base of the mane, and the details of the face. Then I "ground" the foal with a dark cast shadow.

# CANTERING FOAL

By the time a foal is one year old, many of the baby characteristics are gone, but it is still obvious that the horse is a youngster. Most horses will reach full maturity by the age of five. By their second birthday, many breeds are already under saddle—and some breeds, such as the Thoroughbred and Standardbred, start their racing careers at two years of age. These horses have universal birth dates of January 1st, regardless of their birth month, so the foals are frequently born in the early months of the year to give them a slight advantage over those born in later months.

▶ **Step One** This foal in action has three feet off the ground—with this tricky position, I am careful not to tip the horse forward in my sketch. Beginning with the HB pencil, I use light strokes and curving lines to establish the body; then I begin defining the bulges and muscles within the outline. I mark the centerline and browline for feature placement.

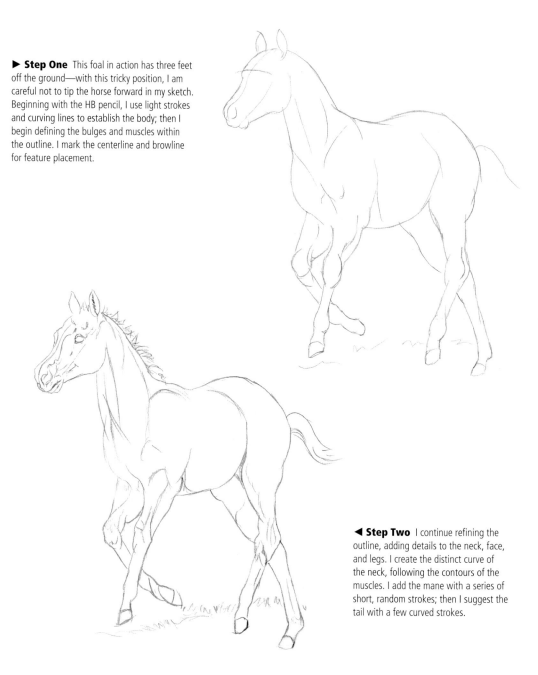

◀ **Step Two** I continue refining the outline, adding details to the neck, face, and legs. I create the distinct curve of the neck, following the contours of the muscles. I add the mane with a series of short, random strokes; then I suggest the tail with a few curved strokes.

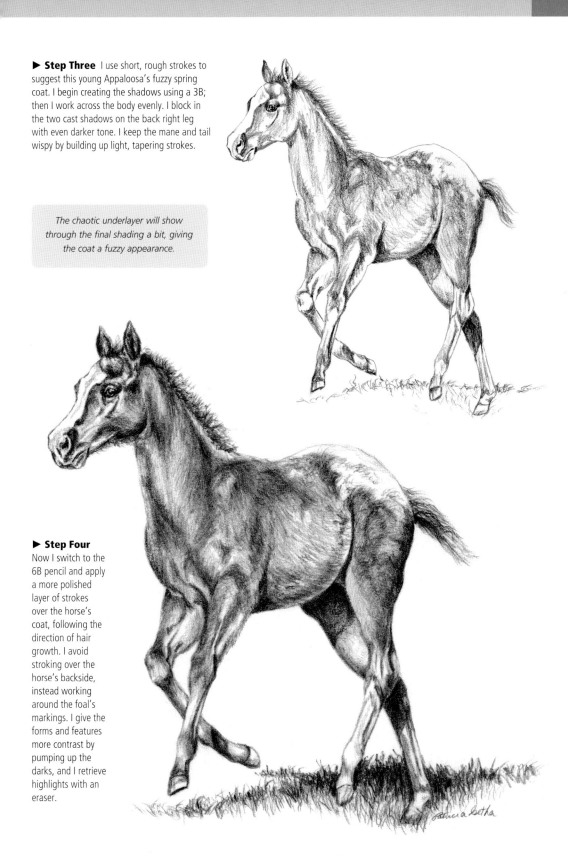

▶ **Step Three** I use short, rough strokes to suggest this young Appaloosa's fuzzy spring coat. I begin creating the shadows using a 3B; then I work across the body evenly. I block in the two cast shadows on the back right leg with even darker tone. I keep the mane and tail wispy by building up light, tapering strokes.

*The chaotic underlayer will show through the final shading a bit, giving the coat a fuzzy appearance.*

▶ **Step Four** Now I switch to the 6B pencil and apply a more polished layer of strokes over the horse's coat, following the direction of hair growth. I avoid stroking over the horse's backside, instead working around the foal's markings. I give the forms and features more contrast by pumping up the darks, and I retrieve highlights with an eraser.

# STANDARDBRED TROTTER

The *trot* is a two-beat, diagonal gait with interesting footwork; the front left and rear right legs move forward simultaneously, followed by the front right and rear left legs. There are points where all four feet will be off the ground at the same time, giving the appearance of a floating horse. This project depicts a Standardbred trotter during a warmup—it is working at a moderate speed, and its body is not fully extended.

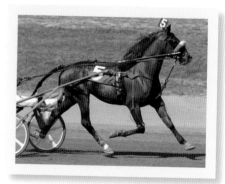

▶ **Defining the Muscles** Because this drawing depicts a competitive horse, it's important to emphasize the fine musculature. I keep the croup flat and the haunches well defined to indicate the propelling power of the hindquarters.

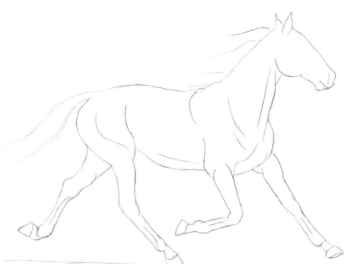

◀ **Step One** I establish the basic outline of the horse using an HB pencil and loose strokes. In this early stage, I keep my lines light, erasing and adjusting as necessary. I add a few lines to block in the forms of the muscles, indicating where the light and dark values meet.

*The Standardbred is known for its skill in harness racing. It is the fastest trotting breed of horse in the world.*

▶ **Step Two** Once I'm satisfied with the basic outline, I refine my lines to carefully depict the subtle curves and angles of my subject, and I use long, tapering strokes to begin rendering the mane and tail. Then I develop the outline to show the muscles, tendons, ligaments, and facial features. As I progress, I note the details in the reference that make this active pose unique. Notice how one ear is tipped back to listen for cues from the driver, whereas the other is facing forward to listen ahead. Also, the visible nostril is slightly flared from the physical activity.

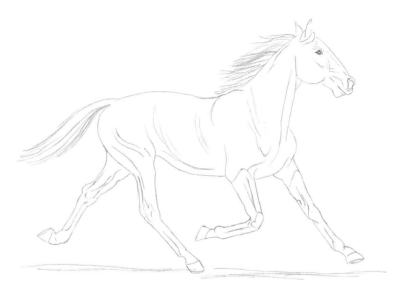

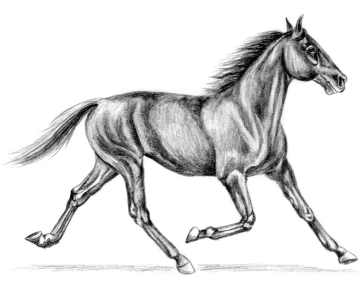

*As you shade, you'll want to minimize the chance of smearing the graphite: If you're right-handed, work left to right; if you're left-handed, work right to left.*

**Step Three** At this point, I switch to a 3B and begin shading the horse to add form. I build up the tone evenly over the horse, starting with the shadows and gradating to the lighter areas. To suggest movement in the horse, I avoid blending to keep my shading rough and sketchy.

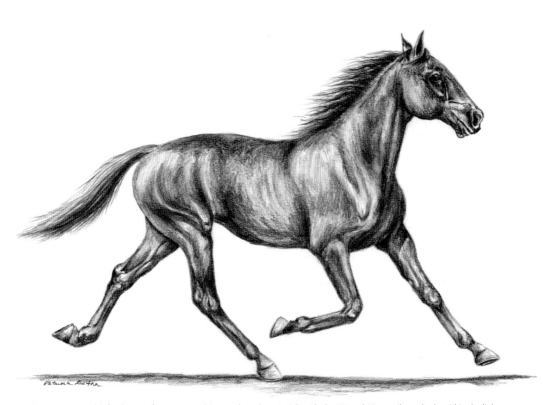

**Step Four** In this final step, I focus on punching up the values. I stick with the HB and 2B pencils to shade within the lighter areas, but I change to a 6B for darker values. It's important to use the softest pencils for the darkest areas, as harder pencils can burnish the graphite, causing odd reflections or even damage to the paper's surface.

# AMERICAN SADDLEBRED & RIDER

The exaggerated and animated gaits of the saddlebred are delightful to draw. The feet of this breed are specially shod with heavy shoes and longer horns, which help enhance the action and give this horse a graceful, stately look. To convey the elegance of this breed and rider, use fluid washes of black watercolor to add more depth to your drawing. (See page 11 for more information on watercolor washes.)

*Keep all your lines light so they don't show through subsequent washes.*

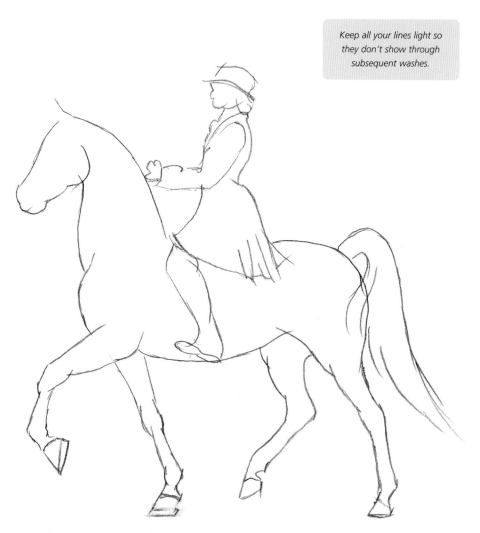

**Step One** Using an HB pencil, I lightly sketch the basic body shapes of the horse and rider on a sheet of heavy paper. I create each stroke with light pressure, as I want to avoid scoring the paper's surface with the pencil tip. I'll also want to avoid erasing too frequently, as this also can damage the paper and affect later applications of watercolor.

Before moving on to the
watercolor washes, "ground"
the horse by adding a few
horizontal strokes.

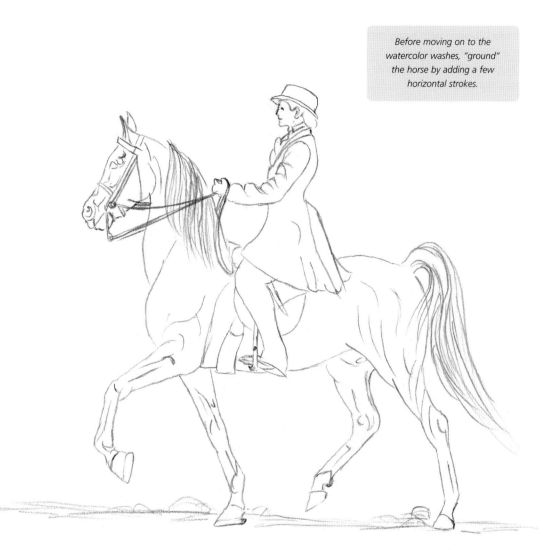

**Step Two** With the basic shapes in place, I refine the outline and add details throughout to indicate curves, bumps, and folds in the horse's skin and the rider's clothing. Then I carefully place the horse's facial features and tack, and I begin building up the mane and tail with gently curving strokes.

*Remember that watercolor isn't as
permanent as it may seem—you always
can "lift out" mistakes or lighten values
using a damp brush and a piece of
paper towel or cotton swab.*

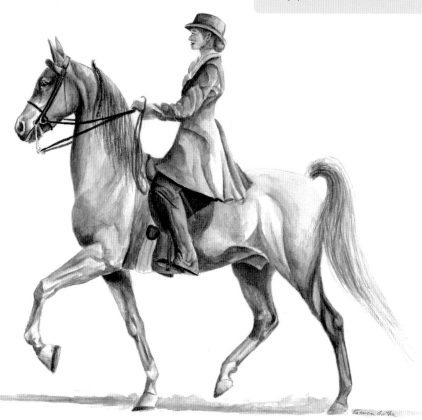

**Step Three**  Using a paint palette with several mixing wells, I mix several different values of
wash, ranging from black to very pale gray. I start applying tone using a very light wash, working
first in the shadows; then I build up to the darks using successively darker washes. (If you happen
to apply a value that is too dark, simply load your brush with water and blend the wash directly
on the paper.) For the mane and tail, I use the drybrush technique (see "Watercolor Washes" on
page 11), moving the brush in the direction of hair growth. To add fine details, I use a dark wash
and the tip of the brush.

*Many saddlebreds are five-gaited, able to execute not only the walk, trot, and canter, but also
the slow gait and rack. The slow gait is a four-beated gait performed in a prancing motion; the rack
is a much faster version of the slow gait, with the horse snapping its knees and hocks up quickly.*

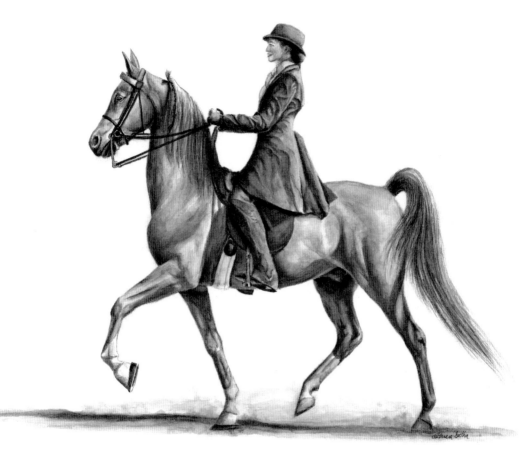

To darken the mane and tail, drybrush with a darker wash than in step 3, and then soften the strokes with a slightly wet brush.

**Step Four** I continue building up the forms of the horse and rider with layers of paint, allowing the washes to dry between applications. This technique of layering, called "glazing," allows for a slow, controlled buildup of value and produces smooth, silky gradations. Once the shadows reach the desired value, I tighten and polish the drawing, carefully defining the folds of fabric and the creases of the limbs.

# GYPSY VANNER

The "Gypsy Horse," known in America as the Gypsy Vanner, is a hardy horse bred by Gypsy Travelers to pull their ornate caravans and carts. The Gypsies lived in these caravans, traveling from camp to camp with their families. This type of horse may also be called the Gypsy Cob, Irish Cob, and Romany Horse. They can be any color and generally have long, thick manes and tails, along with an abundant amount of leg feathering. They have a stout, muscular body type like larger draft breeds but are much smaller in stature. Still rare in the United States, the Gypsy Vanner is gaining popularity with horse enthusiasts around the world.

This project depicts a Gypsy Vanner stallion. Notice his thick neck, muscular body, and long mane and tail. His feathering, common with many larger draft breeds, starts just below the knee joint and completely covers the hoof.

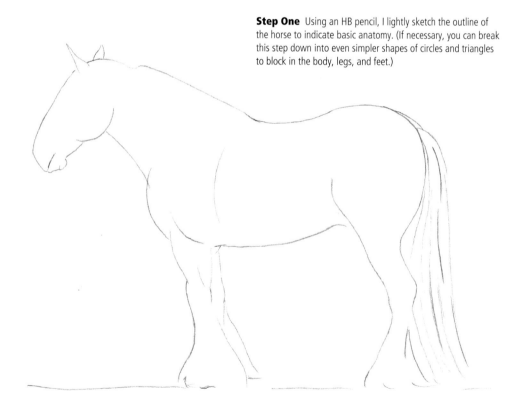

**Step One** Using an HB pencil, I lightly sketch the outline of the horse to indicate basic anatomy. (If necessary, you can break this step down into even simpler shapes of circles and triangles to block in the body, legs, and feet.)

▼ **Step Two** I add more anatomical elements and refine my outline. I also delineate the large shapes that make up the coat pattern, keeping my lines loose and light so I can erase them later if necessary.

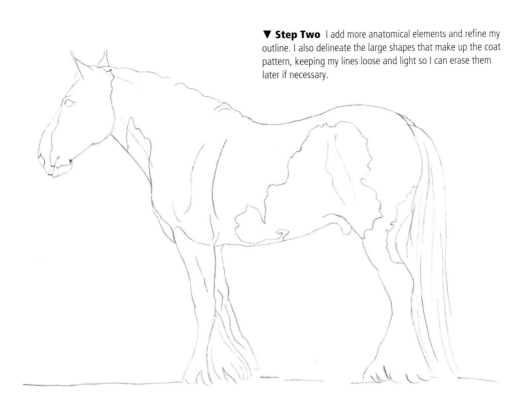

▼ **Step Three** In this stage, I begin to add tone to give my drawing a sense of form. I look at the final drawing and notice the strong light patterns on the horse. This play of light over the horse's back and down his side defines the muscle groups, therefore it should be captured accurately. I continue using an HB pencil and lightly lay in the middle and dark tones across the body, using a bit more pressure in the darker areas.

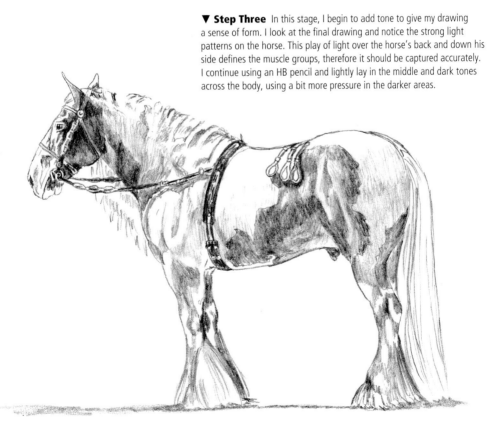

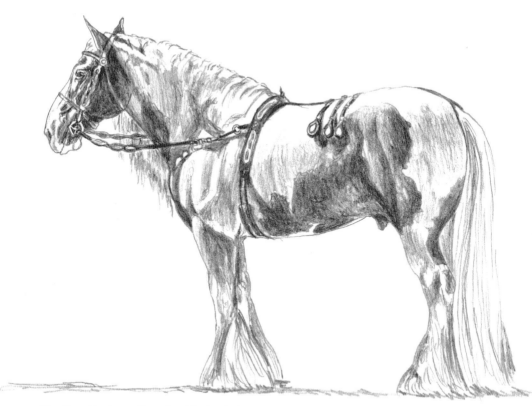

**Step Four** Here I use a 3B pencil and develop the form a bit more by adding darker shadows, including the subtle shadows in the white areas. These white areas can present quite a challenge when rendering them in pencil. Look at "white" things in your own environment and notice the various colors and values within them that help define their forms. The same holds true for "black" areas. The challenge of pencil drawing is the task of accurately assigning a range of values to each area. Sometimes it helps to imagine breaking down each value into a percentage, black being 100 percent or the darkest areas and white being 0 percent.

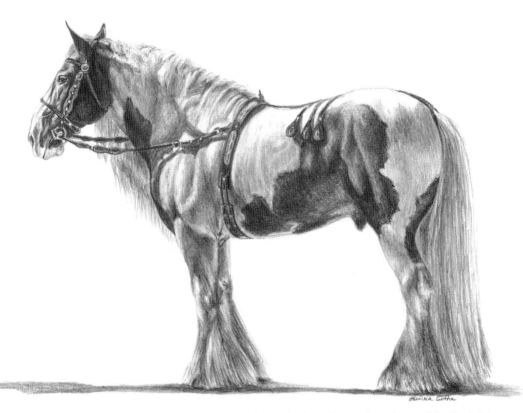

**Step Five** In this final stage, I increase the contrast and refine the details. I make sure all my values are defined in the lighter areas, and I darken the shadows with a 6B. If you prefer a softer look to your final drawings, you can blend your strokes with a tortillon.

# AMERICAN PAINT HORSE

The American Paint Horse Association (APHA) is the second-largest breed registry in the United States based on the number of horses registered annually. One of the most notable traits of the American Paint is the presence of a colorful coat, which is one of three patterns: overo, tovero, and tobiano. The American Paint Horse has a stocky build, similar to that of the American Quarter Horse. This project shows a stocky Paint mare, which exhibits the overo coat pattern. Her body is slightly foreshortened through the barrel. Remember that sometimes a camera lens can make the head appear too large. If you work from photographs, it is important that you do not transfer this distortion to your drawings, as they are more obvious in artwork than in photographs.

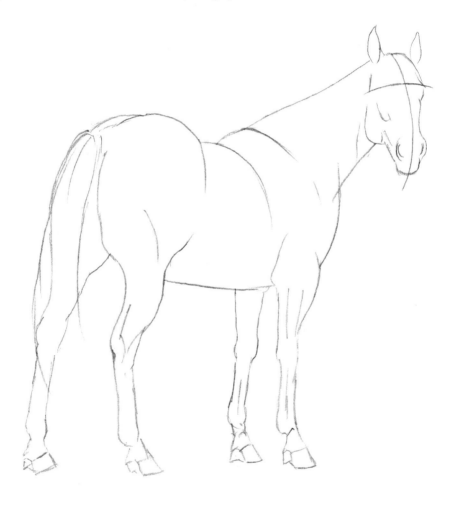

**Step One** Using an HB pencil, I block in the basic shapes and outline of the horse. Her body is slightly foreshortened through the barrel, so I'm careful to make up for any distortions in my reference. Some camera lenses tend to distort objects taken from this angle—the rump may appear too large in relation to the rest of the body, and the head may appear much smaller and farther away. I retain a sense of the foreshortening in my drawing, but I avoid transferring this exaggerated distortion; these qualities become more obvious in a drawing. Notice that the backs of the pasterns and heels of the feet are visible. I am careful to watch the angles of the feet, making sure they appear accurate.

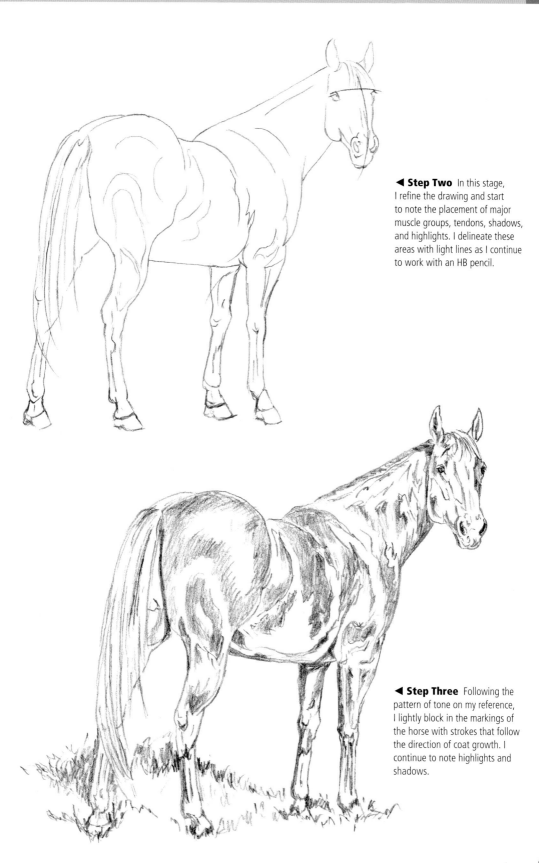

◄ **Step Two** In this stage, I refine the drawing and start to note the placement of major muscle groups, tendons, shadows, and highlights. I delineate these areas with light lines as I continue to work with an HB pencil.

◄ **Step Three** Following the pattern of tone on my reference, I lightly block in the markings of the horse with strokes that follow the direction of coat growth. I continue to note highlights and shadows.

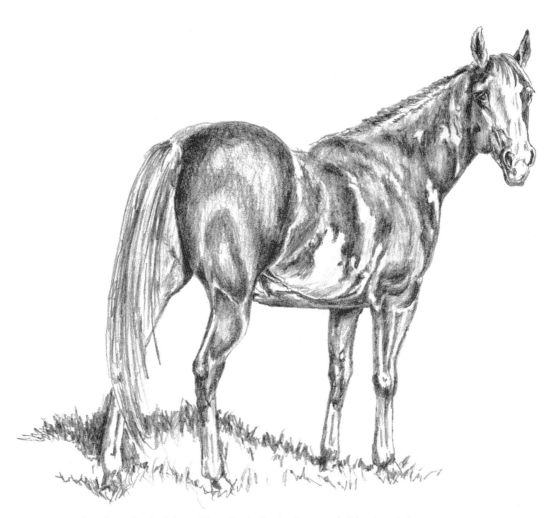

**Step Four** Here I switch to a 3B pencil and refine the placement of all the elements. I use a bit more pressure in the darkest shadow areas and pick out any highlights that may have been accidentally filled in using a kneaded eraser. By this point, I start to see a definite coat pattern developing, and the limbs and body begin to appear rounded and three-dimensional.

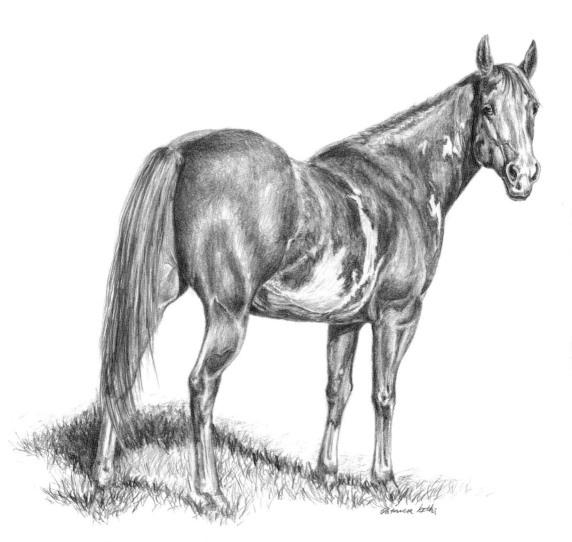

**Step Five** For the final stage of the drawing, I switch to a 6B pencil and darken areas that need more definition and deeper values. I try to distinguish between the white markings on the horse and the highlights by adding subtle shadows to the white areas. Remember: You can still have highlights and shadows in white areas, so it is important to include a full range of values between white and black. Your final horse should appear to have different "colors" on its coat. To develop the grass, I use a sharp 2B or 3B pencil and make quick, upward strokes of varying weight and value. I vary the direction of the strokes so they look random, using sharper strokes in the foreground and softer strokes in the background for a sense of depth. I also blend the distant grass so it further recedes from the viewer.

# PINTO PONY

Ponies can present some unique challenges to the working artist. Some are so hairy that you can't see their features—it's a wonder they can see where they are going at all! Others are very fat with short legs and hair that hides everything else. The pony in this project is a pinto—not any special breed, but cute all the same. He is a working pony who had just finished taking kids for rides at the zoo. My photo reference captured him reaching around to scratch his rear pastern.

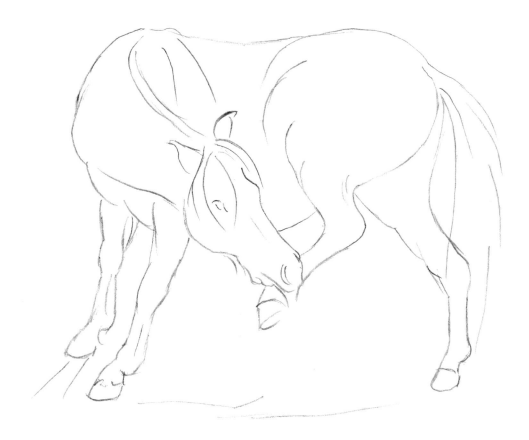

**Step One** I start this drawing by lightly blocking in the outline of the body. I indicate the lines in the neck so that when I start shading and adding the mane, I understand how the anatomy would look under all that hair. It is not often that one has the opportunity to sketch a horse in this position, therefore it is important to study the anatomy whenever possible so you can render it accurately. While creating the outline, I notice how various parts of the body line up with one another and compare in size; for example, the withers are the same height as the rump. Picking up on details like this will help you achieve an accurate initial sketch.

**► Step Two** I continue to block in the muscle groups, tendons, markings, and shadows. I also indicate where color changes occur and lightly rough in the mane and forelock, stroking in the direction of hair growth. I keep my lines fairly light so I can easily erase or draw over them where necessary.

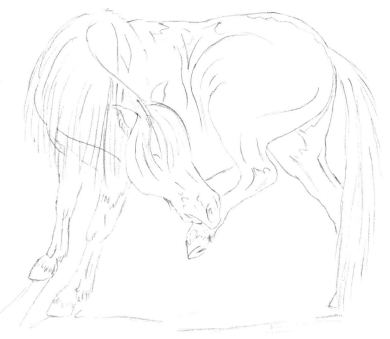

**▼ Step Three** In this step, I lightly block in the basic values with quick strokes that follow the natural flow of the coat and hair. I pay particular attention to where the direction changes course, such as in the hip area, to keep it as realistic as possible. I keep in mind that there is a very strong light source illuminating the back and top of the withers, creating highlights that will help define the muscles, wrinkles, and anatomy of the pony. Re-creating these effects of backlighting adds contrast and drama to the scene.

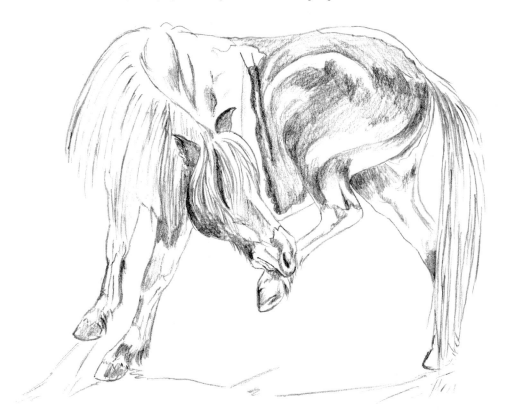

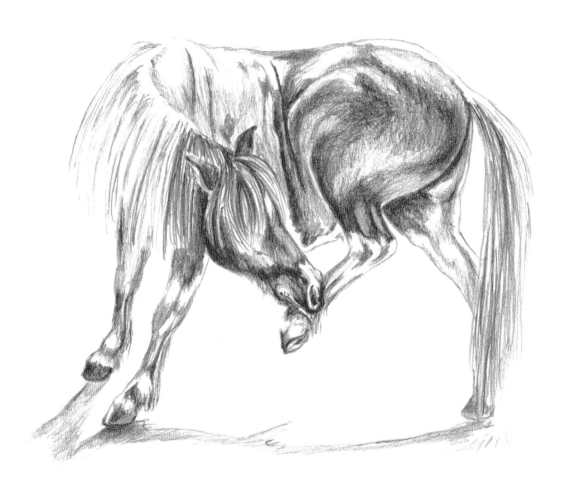

**Step Four** I continue to develop the shadows with a 3B pencil. Because of the strong light on the withers, I don't find a lot of detail in this area, but I still lightly indicate what should be there and suggest the top line of the neck. Using a very sharp 2B pencil, I refine the mane with long, tapering strokes of varying pressure, keeping the lightest areas free of tone. (You may choose to blend this area and soften the strokes with a tortillon.) If the strokes get too dark, I pick them out with a kneaded eraser. I keep on hand a simple, inexpensive barbecue brush (purchased at a grocery store) to brush away any eraser crumbs. Also, I often use a clean sheet of paper to cover areas of the drawing I've worked on to prevent the graphite from smudging, especially in the darker areas.

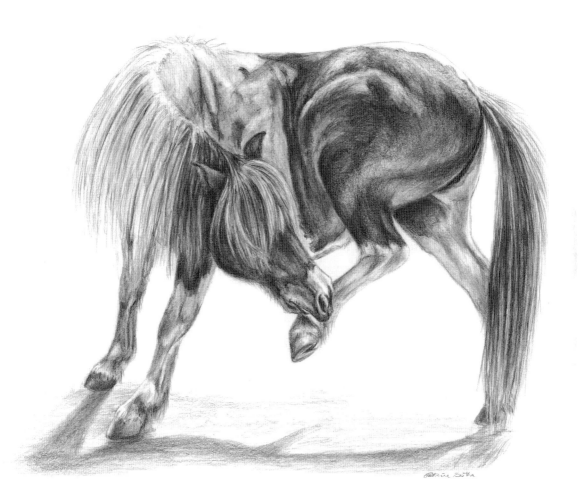

**Step Five** I finish the drawing by darkening all the shadow areas using a 6B pencil. As I create the cast shadow, I keep in mind that it should always reflect the texture of the surface it appears on. If the surface is rough, the shadow should appear rough as well. If the surface is smooth, blend the shadow to reflect a smooth, uniform texture. As I shade the body, I am especially careful not to lose the nice wrinkles caused by the long stretch of the neck and the body folding in on itself. I often see horses hike up a hind leg and scratch an ear with the hoof like a dog. They must accomplish this while standing, so it is somewhat comical to watch—you would think that a horse would not be able to do this without hurting itself!

# AMERICAN MORGAN HORSE

The American Morgan Horse dates back to 1789 when a man named Justin Morgan purchased a bay colt named Figure, which became the foundation sire for the breed. His offspring influenced many other breeds, such as the American Saddlebred, American Quarter Horse, and the Standardbred Trotter. Known for their beauty, strength, speed, endurance, and gentle disposition, the Morgan horse quickly grew in popularity and spread around the young nation. They were used as Calvary horses in the Civil War and carriage horses in everyday life. Today's Morgans compete in many disciplines, from combined driving and carriage events to dressage.

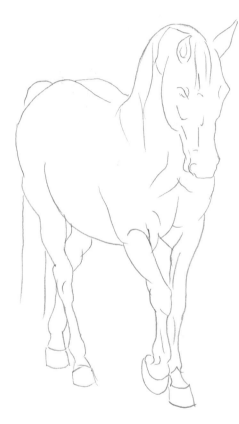

**◄ Step One** This project depicts a Morgan Carriage Horse in a three-quarter view. The body of the horse is foreshortened, so the front hooves appear slightly larger than the hind hooves. In a foreshortened view, it's important to accurately draw these subtle differences so the drawing appears correct to the human eye. Photographs do not always accurately depict foreshortened subjects, so I'm always careful to examine my reference for errors in perspective, which are more noticeable in a drawing than in a photograph. To begin, I lightly draw the basic outline of the animal using an HB pencil. I keep the lines light as I draw so I can erase and refine them in later steps.

*This Morgan Carriage Horse is shown at a foreshortened, three-quarter view. Notice that the front hooves are slightly larger than the hind hooves. In a foreshortened view, be sure to include these subtle differences so your drawing appears correct to the human eye.*

**► Step Two** From this initial outline, I create a more detailed sketch of the horse, indicating the major muscle groups and the hair. I also rough in areas of highlight and shadow. At this point, I can dissect my reference with lines and curves to help me see where various anatomy structures align with one another.

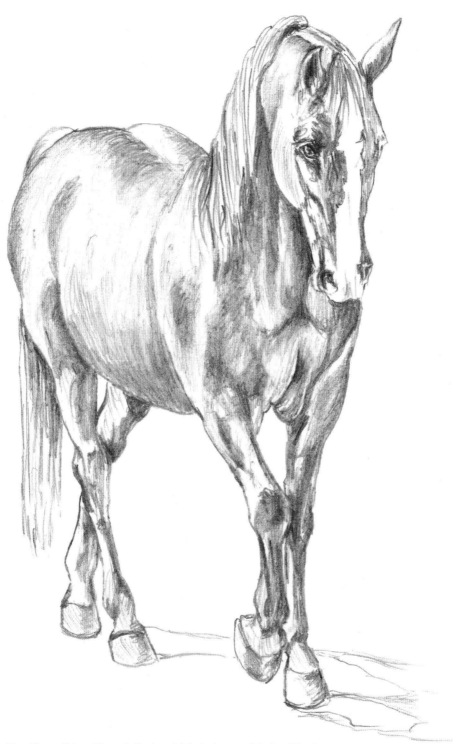

**Step Three** Using a 3B pencil, I begin to lightly shade areas of shadow. I blend my graphite with a paper tortillon to soften the look as I go. A horse in summer typically has a very short and shiny coat that reflects a fair amount of light. Blending the graphite is a great way to capture the smoothness of the coat. Using a sharp pencil, I rough in the mane and tail with fine, light strokes. I will build upon these strokes in the next two steps.

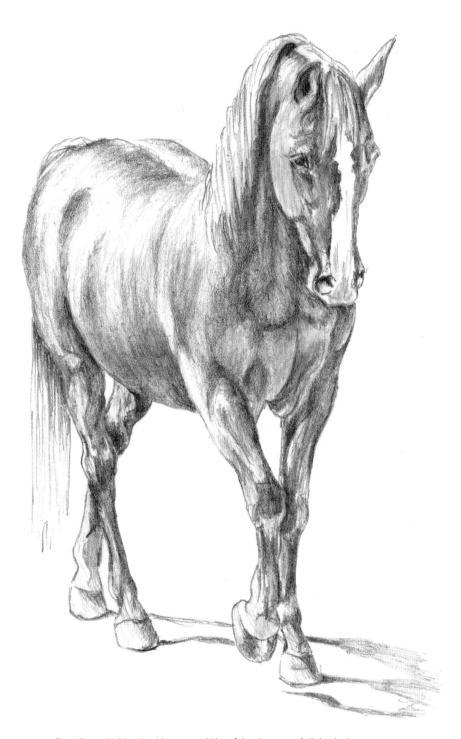

**Step Four** At this point, I have a good idea of the placement of all the shadows and highlights. I continue to build layers of graphite with a 3B pencil (you can go even softer, if you like), blending with the tortillon as I go. I restore any highlights that have been covered with tone using a kneaded eraser.

**Step Five** In the final stage, I switch to a 6B pencil and darken the shadows. I try to indicate the veins and tendons, which are typically visible on a horse at work. This will add realism to your drawings. Sometimes it's difficult to render realistic "white" areas in graphite, as they are not always pure white. I am sure to indicate this in my drawings to give them form and depth. It's also important to distinguish the white areas of the coat in shadow from the non-white areas in the light. To accomplish this, I am careful to use a different range of values within each "color" of the coat.

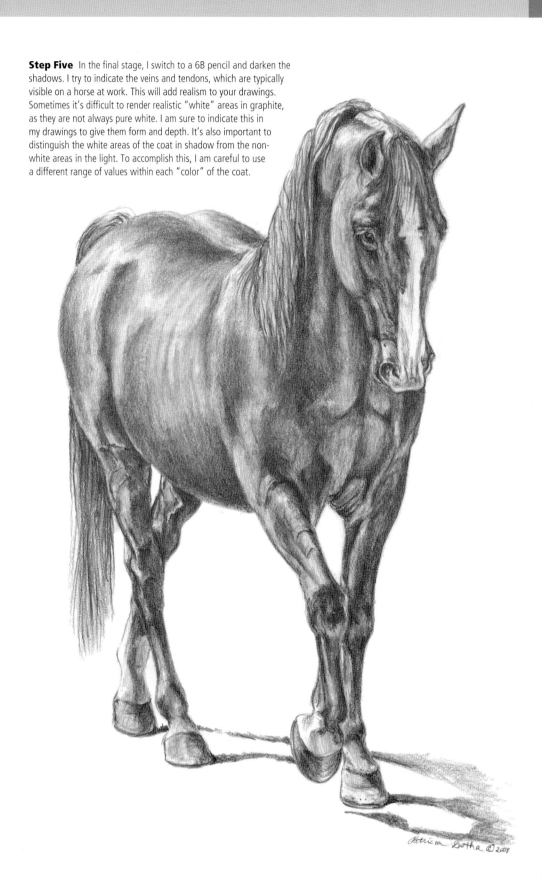

# DAPPLED PONY

This pony presents somewhat of a challenge to the artist: He is a bit overweight and has a dappled coat pattern. An overweight animal hides underlying skeletal and muscular structures, so it becomes difficult for the artist to render areas where these structures exists, altering the way light reflects off the animal. As your knowledge of the anatomy grows, so will your drawing skills for rendering areas of the body—and you will become familiar with the way certain bones, ligaments and muscles should appear. You can use this knowledge to "fake in" areas that may not be apparent in your reference.

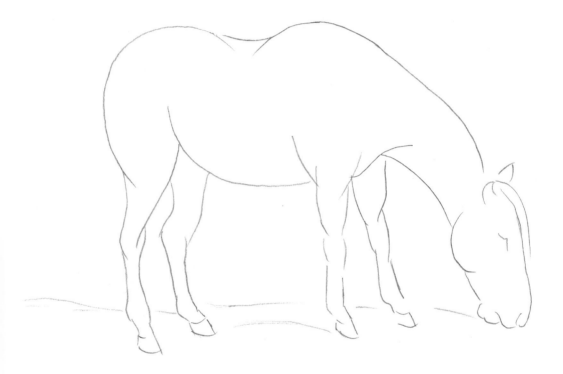

**Step One** I start by blocking in the main forms of the body, legs, and head. Notice that I draw the arch of the neck even though this area is hidden in the final drawing; it's always important to have a sense of the underlying shapes and alignments. I also rough in the hooves. Hooves are difficult to draw, even for seasoned artists. It is worthwhile to practice drawing them from different angles, even if they don't appear in your final drawing. While it is sometimes a challenge to draw from life, this is the best way to see firsthand how all the parts of the body come together. Photographs tend to flatten forms, making it difficult to determine just how something should look.

▼ **Step Two** Building on the sketch from step one, I create a detailed outline of the horse, indicating the position of various anatomical structures, highlights, and shadows. I keep my lines light so I can alter them as I progress. I use an HB pencil for this step, as this lead is neither too hard nor too soft. As a general rule, I use an HB for sketching and reserve hard pencils for light areas and soft pencils for the dark areas. A 3B pencil is great for creating midtones.

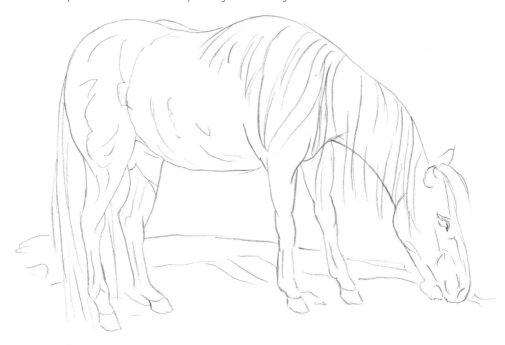

▼ **Step Three** Step three is a natural progression into step four. I start by laying in the shadows, which help create form and dimension in the drawing. I keep my initial values light and layer the graphite to build the values. I also continue building the mane with long, tapering strokes that curve to suggest the forms of the neck and back.

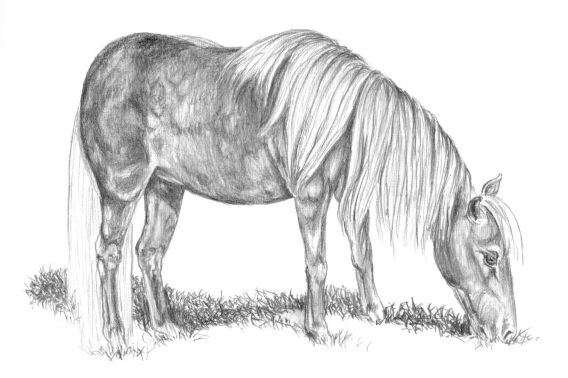

**Step Four** I don't actually draw individual dapples on the coat. Rather, I blend the values together and then carefully pick out the lighter areas with a kneaded eraser. I am careful to keep the edges soft; hard edges will make the dapples appear unnatural. They should blend into one another and reflect the way the light falls on the body, so the dapples in shadow should appear slightly darker than those in the light. I keep the dapples somewhat random so they look natural, avoiding a patterned look. After picking out the dapples, I lightly shade over the top of them, gradating to a lighter tone toward the bottom of the barrel (torso). For this stage, I switch to a harder lead so I'm not tempted to get too dark.

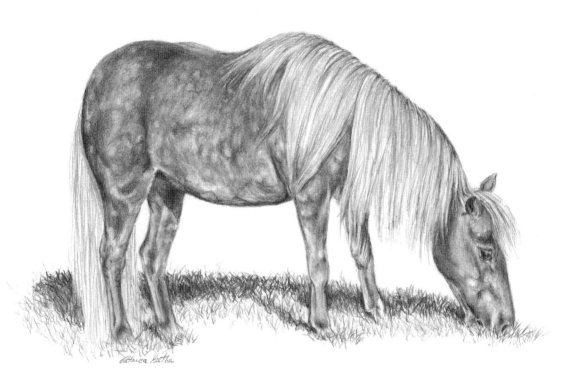

**Step Five** I continue adding dimension to my drawing by lightly shading the areas receiving little or no light. I clearly indicate the direction of the light by developing the cast shadow on the grass. Using a sharp pencil, I lay in quick, upward strokes of varying values and direction to indicate the texture of the grass. The mane and tail are much lighter than the body, so I am careful to maintain this distinction by leaving areas of lighter strokes intermixed with darker ones. The top of the mane does not have as much light shining on it, so I use slightly darker strokes along this area. Now my drawing is complete.

# FRIESIAN

An ancient breed with Spanish influence, the Friesian is an elegant, large-boned horse originating from the Friesland region of the Netherlands. The Friesian is almost always black with minimal (if any) white. A pure white Friesian has recently been bred and is the product of Arabian bloodlines that have been introduced with special permission from the Breed Association. These versatile horses were originally used in farming, the circus, and war. Today's Friesian is a popular performance horse known for its proud carriage, arched neck, and high-stepping action. While this drawing can seem intimidating due to the amount of hair, breaking the hair down into several steps will make it much easier. The first step involves seeing what is not there: the curvature of the neck. Establishing this curve provides a reference point for the rest of the drawing. Shapes and lines help develop the form of the horse; they provide the guidelines for creating form through shading.

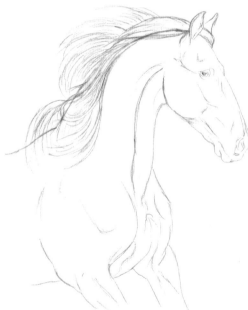

**Step One** Using an HB pencil, I begin by establishing the basic outline of the horse. Note the curvature of the neck, which will be hidden under the mane in the final steps. I keep my lines loose and sketchy. I don't worry about shading at this point, but focus instead on how lines and shapes relate to one another. It helps to view the mane as a shape rather than individual hairs. You may also indicate individual features such as the eye, nostrils, ears, and muscles.

**Step Two** With the same pencil, I further define the shape of the horse. I start building on the lines from the initial sketch, establishing accurate curves for the ears, muzzle, eye, and muscle structure of the neck. I continue using light, overlapping strokes to establish the direction of hair on the mane. Once I'm happy with my sketch, I transfer it to a clean sheet of paper.

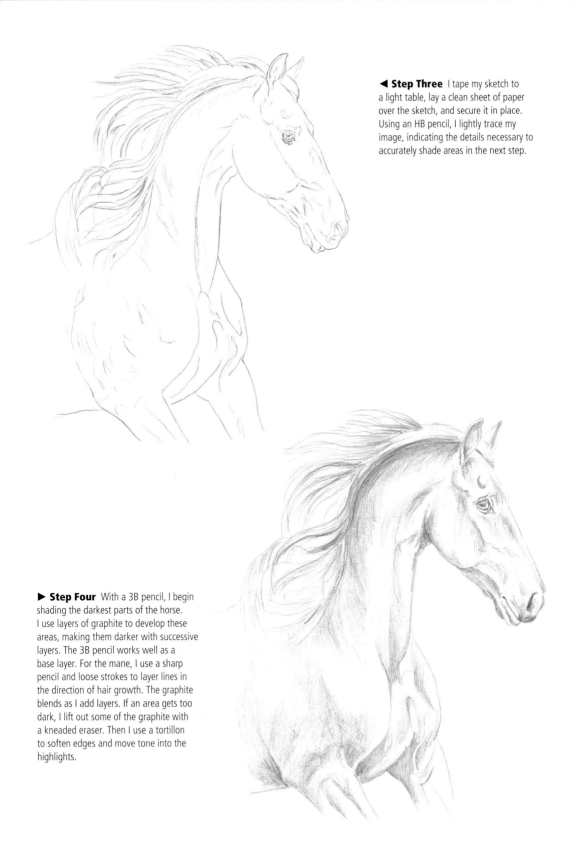

◄ **Step Three** I tape my sketch to a light table, lay a clean sheet of paper over the sketch, and secure it in place. Using an HB pencil, I lightly trace my image, indicating the details necessary to accurately shade areas in the next step.

► **Step Four** With a 3B pencil, I begin shading the darkest parts of the horse. I use layers of graphite to develop these areas, making them darker with successive layers. The 3B pencil works well as a base layer. For the mane, I use a sharp pencil and loose strokes to layer lines in the direction of hair growth. The graphite blends as I add layers. If an area gets too dark, I lift out some of the graphite with a kneaded eraser. Then I use a tortillon to soften edges and move tone into the highlights.

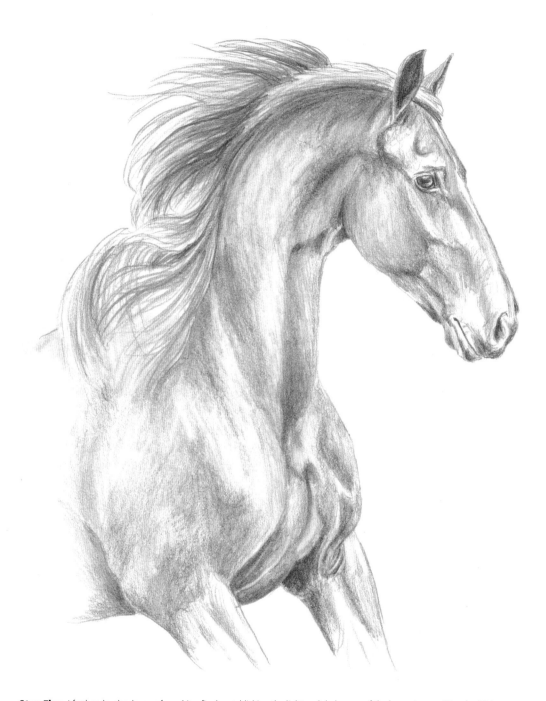

**Step Five** I further develop layers of graphite, firmly establishing the light and dark areas of the horse. I use a 6B and a 9B to create the deepest shades of black. At this point, the form is clearly developing and the muscles appear rounded. The smooth coat should start to appear shiny in the highlighted areas. Even though the Friesian is a black horse, it is important to include light areas that define and shape the surface of the animal, giving the illusion of depth and form.

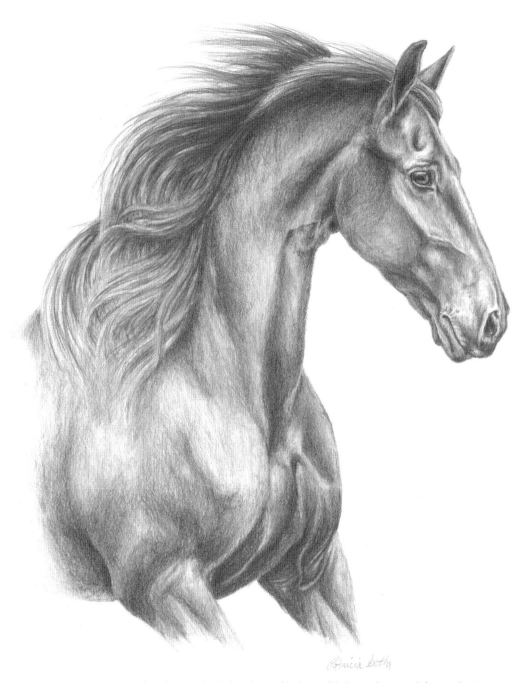

**Step Six** With a 6B, I add layers of graphite over the shadowed areas, blending and darkening them. I apply firm, overlapping strokes in the shadows of the mane and lighter strokes in the lightest areas. Using a stick eraser, I define the lighter hair that overlaps the dark areas of the mane, keeping the strokes soft by blending them with a tortillon and lifting out light areas with a kneaded eraser. I use the side of my pencil to cover larger areas with graphite, blending with a tortillon as I go. Finally, I take time to study the eye and nostrils, paying close attention to how the light and dark areas make these areas appear realistic (see "Anatomy & Features" on page 7).

# ANDALUSIAN/LUSITANO

The Andalusian/Lusitano horse is one of the oldest breeds in the world, having been depicted in cave paintings dating back 25,000 years. Originating from the Iberian Peninsula, which includes the modern-day countries of Andorra, Portugal, Spain, and Gibraltar, this horse was used in war and was greatly admired by the Greeks and Romans, who adopted the Iberian Horse and set up their own breeding facilities in Baetica (modern Andalucîa). Today's Andalusian and Lusitano horses are not only beautiful, but their natural ability and grace make them the ultimate riding horse.

This is a gray horse, so the values are much lighter except where bare skin is showing. Many gray horses have darker dappling over the rump and on the legs. Even though this horse will likely turn lighter with age, it has dark skin, which is apparent on the muzzle, around the eyes, and in the groin area. Use these values to your advantage by accentuating them to create contrast.

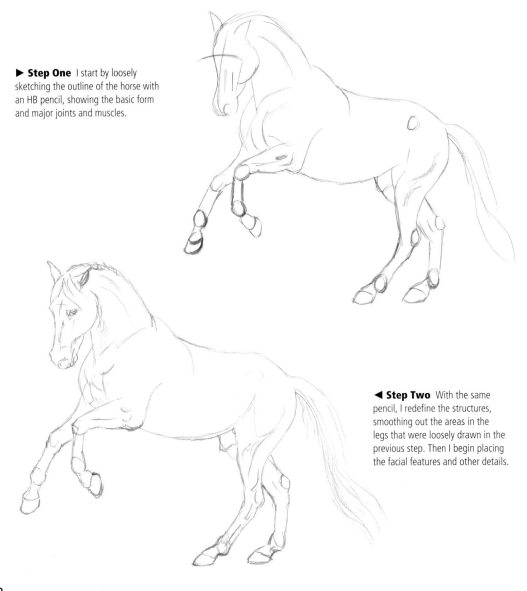

▶ **Step One** I start by loosely sketching the outline of the horse with an HB pencil, showing the basic form and major joints and muscles.

◀ **Step Two** With the same pencil, I redefine the structures, smoothing out the areas in the legs that were loosely drawn in the previous step. Then I begin placing the facial features and other details.

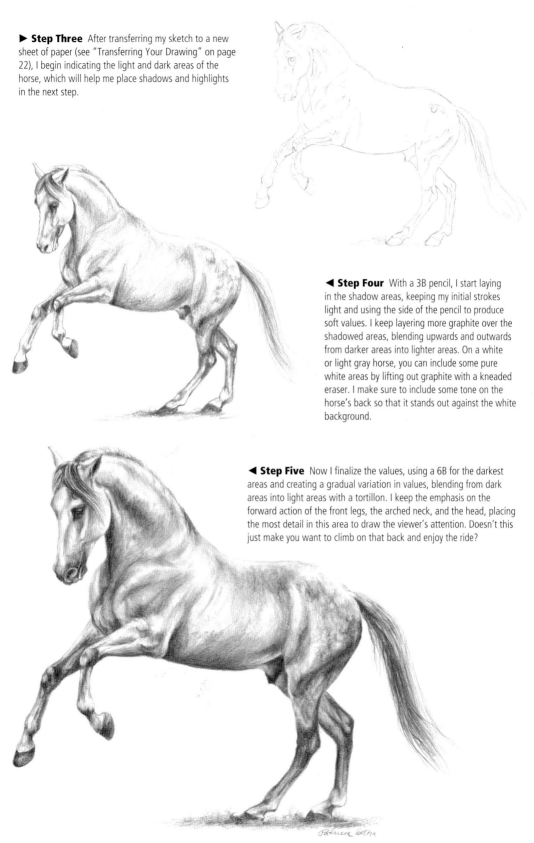

▶ **Step Three** After transferring my sketch to a new sheet of paper (see "Transferring Your Drawing" on page 22), I begin indicating the light and dark areas of the horse, which will help me place shadows and highlights in the next step.

◀ **Step Four** With a 3B pencil, I start laying in the shadow areas, keeping my initial strokes light and using the side of the pencil to produce soft values. I keep layering more graphite over the shadowed areas, blending upwards and outwards from darker areas into lighter areas. On a white or light gray horse, you can include some pure white areas by lifting out graphite with a kneaded eraser. I make sure to include some tone on the horse's back so that it stands out against the white background.

◀ **Step Five** Now I finalize the values, using a 6B for the darkest areas and creating a gradual variation in values, blending from dark areas into light areas with a tortillon. I keep the emphasis on the forward action of the front legs, the arched neck, and the head, placing the most detail in this area to draw the viewer's attention. Doesn't this just make you want to climb on that back and enjoy the ride?

# CLOSING WORDS

In closing, I would like to note that while drawing horses is very challenging, the end result is incredibly rewarding. If you can learn to draw a horse, you should be able to draw other animals easily. Be patient with yourself; it has taken me a lifetime to get to this point and I still learn something new every time I draw a horse. I recommend spending as much time as possible getting to know your subjects, studying their lines and underlying bone and muscle structure, and taking special note of how they relate to one another. You can try adding color to your drawings, too. Colored pencils are an easy and inexpensive way to incorporate a bit of color into your drawings, and you can use similar techniques to those discussed in this book. Have fun drawing horses—I sure do!

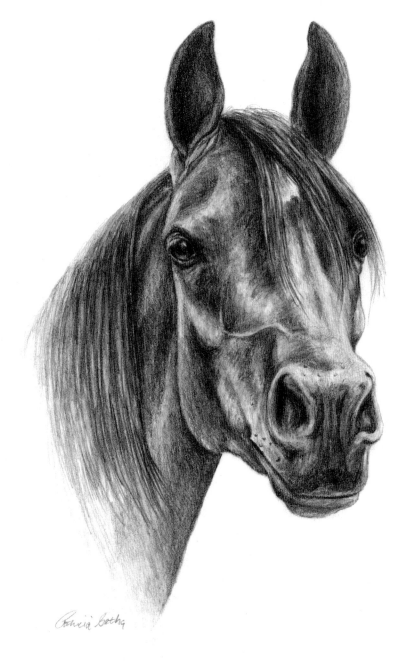